THEMES
1. FEAR
2. GRATITUDE
3. FAMILY
4. PARENTHOOD
5. AFRICAN ROOTS
6. TALENT &AMBITION
7. DISCRIMINATION

Poem 1

To feel the heart pound,
Making that noise that she fears,
She tries to rise,
What rises is the relaxed dust,
He and others watch helplessly.

She gropes around whispering,
A shy whisper that cannot wake a mosquito,
She hears a noise,
He and others gasp in horror.

FEAR

She stands up and stumbles,
Stumbling like a drunkard,
She maintains her posture,
He and others raise their eyebrows.

For a moment they stare in disbelief,
For it's a miracle,
A miracle that they feared was never coming,
She walks out of the hospital room.

Poem 2

What if I sleep and don't wake?
What if I don't find my purpose?
What if am not strong enough ?
What if I don't get successful?
What if my child gets unruly?
What if my life is brought to a standstill?

What if those I love give up on me?
What if am not enough for my family?
What if am not destined for greatness
What if I don't have my life in shape?
What if I am so drowned in loving?
What if my loved ones are no more?

What if I can't change with time?
What if I am on the verge of a breakdown?
What if I never get up after my fall?
I am surrounded by so much fear?

Poem 3

The results came,
The long-awaited,
No one was in a rush,
To confirm the inevitable.

The drop silence,
Spoke volumes,
No one dared to imagine,
Bowing to the pressure.

The letter dropped,
Out of a mixture of joy and fear,
To pick it up was the right course of action,
But it remained in the ground.

Poem 4

When you don't feel so beautiful,
When you have no will to live,
When everything seems still,
When life is not all so rosy,
When you feel empty inside,
When your heart grows cold,
When your light stops shining,
When all you feel within is anger,
When things seem not to matter,
When you feel absorbed in fury,
When you are not afraid of hurt,
When you aren't magazine perfect,
When you feel not so confident,
When everything is messed up,
All they ever say is HOLD ON.

GRATITUDE

Poem 5

All my days I get loved the right way,
The unending support and motivation daily,
A listening ear always around to help me ,
My ability to stand for what I believe in,
The courage to face challenges before me,
Moving past my darkest and worrying times,
Having the power to let go and be myself,
Each day I slump forward pick myself, move on,
Knowing my partner is all in, in this with me,
Most of the times am chilled and relaxed,
Not afraid of having to choose over someone,
To my love, respect to you, for keeping it real,
I work towards being a blessing to others,
To the one above, am grateful for your grace,

Poem 6

I am grateful I am alive,
I am grateful I have a family,
I am grateful I am healthy,
I am grateful I have good friends.

I am blessed to have a partner,
I am blessed to have a home,
I am blessed to have an education,
I am blessed to have food on my table.

I am proud of who I have become,
I am proud of my faith in God,
I am proud of my little angel,
I am proud of my loving parents.

I am blessed.

Poem 7

To be able to breath,
Feel the cold ,
Splashing its presence,
To feel the trickle of the rain,
Announcing a new season.

To smile and feel the cheeks hurt,
To watch as they walk down the aisle,
Feel the cameras click,
Announcing a new chapter.

To hear the cry of a newborn,
To grasp their tiny fingers,
Watch as they smile while asleep,
To be driven home,
Announcing a new beginning.

To grasp the hands in prayer,
To chant the gratitude songs,
To be amazed by his mercies,
Unmeasurable and unconditional grace,
Announcing his everlasting love.

Poem 8

To look up at the sun,
Feel its warmth on the skin,
To be grateful for the color yellow.

To run and welcome the waves,
To grasp and feel the water drop,
To be grateful for the color blue.

To smell its fragrance,
Touch the lilies,
To be grateful for the color white.

To drink and relish in the finest brand,
Feel the sweetness of the grapes,
To be grateful for the color red.

To feel the soil and anticipate the harvest,
To sit and enjoy the maize,
To be grateful for the color black.

Poem 9

My world revolves around them, they are filled with beauty,
Always sure of having a shoulder to lean on, always willing to help.
A very loving and hardworking mum goes against all odds,
Blessed to have a support system, when at your lowest.
At times we fight but it ain't overshadowed by our love,
Our dad an exceptional man, strived to make sure we get an education,
A kind of family with gifted people singers and all.

Faith instilled at an early age, we had to get knowledge about God,
Our core value is ensuring there is unity amongst us,
No matter our differences nothing outdoes the gift of family unity,
So in each day we try and accommodate each other always,
At times things get fiery but there always someone to cool it off,
Respect is paramount in our lives, young and old alike,
As I live each day, I pray we all continue with our love for each other.

Poem 10

Amidst all the unending pain,
Is this kind of love within?
You hold on tied by a chain,
Several years you don't strain,
In a heavy heart, you contain,
A love that isn't all in vain,
Many at times crying in the rain,
Yet end up smiling once again,
So if ever I try to get on a train,
It would be more of joy than pain,
My small unit I call family

Poem 11

The aroma rent the air,
Activity ongoing,
Tulia carry the hotpot,
James take the fried goat,
Grace carry the plates,
Mama sat and watched.

The table was set,
Hands washed and ready,
Prayer finalized,
Everyone with their share,
Mama smiled, illuminating the room.

Remove the plates,
Carry the leftovers,
Wipe the table,
Mission accomplished,
Mama stood up and walked away happy.

Poem 12

We sat on the floor,
coz we could not hold ourselves from the tickles,
The jokes came one after the other,
At some point, we had to hold our hands up,
Final surrender.

We looked at the album next,
Smiled after each photo coz we remembered,
The laughter and joy that we had,
Our cheeks hurt as we came to the last photo.

We sat together in the dining room then,
One meal after the other,
Everyone had their favorite,
There was pilau, chapati, rice, stew, chips and
chicken for the children.

The happy moments made life bearable,
There was the hardship but it was kept
in the shadows,
The heartache and disappointment not
given a chance.

PARENTHOOD

Poem 13

Some days are exhausting,
Some days are interesting,
Some days are challenging,
Some days are chilling.

Some days are stressful,
Some days are wonderful,
Some days are eventful,
Some days are cheerful.

Some days I break down,
Some days in fear I drown,
Some days I have to frown,
The joy of being a parent.

Poem 14

In my youthful years, you came into my life,
My pretty little cherub so precious to me,
Welcomed me into parenthood a bit early,
Found me still trying to find my purpose,
So you became my little work of art.
Living every day to make sure you are happy,
In turn, you gave me joy never thought I'll get,
Most times am so invested in being a parent,
I forget I have to get a life of my own.
Having a baby is one of the greatest treasures,
To her dear father, she is his ray of sunshine,
Gave him the will to become a better person,
Living life beyond ourselves.

Poem 15

I am sorry but it was not my mistake,
It just happened,
I think it's him who did it,
I swear I never saw that on the way,
I cannot pick it up coz I did not drop it,
What! It's not me but him,
OK. Am sorry.

To know the right words to say,
To know when to punish,
To know how-to guide,
To know when to reward,
Is to be a good parent.

Poem 16

She walked in and stepped on something hard,
Hurting her feet,
It was a building block,
She wanted to curse but held her tongue.
She sat on the sofa and felt something pierce her skin,
She stood up suddenly dropping her handbag on the floor,
It was a dart.

She knelt to pick the handbag,
There was something sticky on the lower side,
It was bubble gum.
She walked to the kitchen anxious to have her, leftover meal,
But it was missing and replaced by something sinister,
It was a tomato.

AFRICAN ROOTS

Poem 17

The morning dew,
Walking hurriedly,
To the cow pen to get the milk,
Feet so cold.

The afternoon heat,
Bending in the forest,
Picking firewood,
Head so hot.

The evening breeze,
Sitting on the kitchen stool,
Blowing into the fire,
Hands so tired.

Poem 18

A sound rent the air,
Music and dance was felt,
A woman dressed in a dark cloth emerged,
Children tugged at their mothers.

Young men rose in unison,
Rising to the beating drums,
Covered in red soil,
Ready for the knife.

To be brave and walk among men,
Required sacrifice and they dragged
Billy the goat,
Blood gnashed from the neck,
Women ululated,
Men whistled,
The beginning of the ceremony.

Poem 19

I am from Kenya, Africa,
In a village southwest of my country,
A village full of natural resources,
Farming is our way of life, simply blessed,
A tribe known for having lots of bananas.

My skin is dark, sun-kissed naturally,
In my space, I am proud to be in place,
Every community member makes each other better,
Africa my continent full of diversity,
Proud to be a daughter of my soil.

We are blessed to have each other in life,
We are a group of compassionate and kind humans,
We tie ourselves to the community to keep us safe,
I am African and proud of it.

Poem 20

It tells a story about my origin,
My skin is dark and so beautifully crafted,
Africa a continent filled with love unending,
With most traditions revolving around unity,
Our motherland blessed with fertile lands,
Our regions full of national park and reserves
The most welcoming continent of all,
Our timid ways make us so susceptible,
Children are brought up by the community,
Our traditional attires are so unique,
Our skin tells our history, slavery and all,
We strive to be a successful continent,
I am African and proud to be.

TALENT & AMBITION

Poem 21

My dream is to be successful,
To have a good life before me,
To be surrounded by love,
I desire to have a big family.

My goal is to own an educational faculty,
Provide children with resources to learn,
My mission is to live a purposeful life,
To have a positive impact on my community.

Work on being a good and better person,
I hope I'll always be compassionate and kind,
In this life of mine I pray, my goals I accomplish,
All through this earth a change I make.

Poem 22

Being simple is key, to get through life,
I desire to get a mission not just through it,
At times a knot of guilt tightens through my chest,
About not being able to find what works for me.

I know am clutching through straws realistically nowhere near my dreams,
Consciously aware I can't afford to go wrong and it holds me back,

I try not to think about it but mostly because am engraved in my insecurities,
Knowing what you are good at and not being able to maximize on it is exhausting.

Emotionally ready but being dragged behind
by my mindset of failure,
I desire to have a legacy to myself, I just don't
want to be ordinary,
In all my years I know I am indecisive,
So how about we roam around and find
something exciting,
I wish I could discover my full potential.

Poem 23

To possess a gift and do something about it is being brave,
To stand in a crowd and fight jitters is being courageous,
To encourage others to follow their dreams is being thoughtful.

To know when to bend to pressure is being wise,
To prepare the papers and wait for the future is being prepared,
To encourage others to follow your footsteps is leading by example.

Poem 24

To open shop after shop,
To count both losses and profits,
To watch as the business grows,
To place the discounts and offers,
To mark the growth pattern.

To finish one course after the other,
To be careful of the pass and fail,
To see the results,
Distinction and credits,
To mark life's accomplishment.

To survive through determination,
To be wary of both success and failure,
Shows how being ambitious can change
our destiny.

DISCRIMINATION

Poem 25

To feel alive yet dead,
To stand tall yet stumble,
To laugh out loudly yet sad.

To carry the weight of the world,
To be confused and alone,
To wonder why the accusations,
The finger-pointing.

To cry deep into the night,
To feel empty deep inside,
To examine and feel lost,
To question one's sheer existence.

Poem 26

I have had stares directed at me,
Had people ridicule my features,
Had people take advantage of my calmness,
Lost some opportunities for having acne,
Some people just have a degree in hate.

I have gone to places and got left out,
Have had a lot of doors shut at my face,
Worked with people who think am too dark,
Had people leave because of social class.

I have condoned toxic people in life,
I have made a constant decision to love,
I have been to tribalistic places around,
I have faced people who thought am dumb,
The worst thing about all these fracases, having
to deal with appreciating yourself.

Poem 27

Some people will hate but pretend to love you,
Some people will make sure you don't succeed,
Some of your favorite people could be your enemies,
Some family members would put some expectations on you.
Each day people would put a standard on you,
In schools, a lot of segregations and bullying go on,
In our churches being rich automatically gives people an upper hand.
In leadership, women get little or rather no say at all,
People expect others to look a certain way,
Others want you to have a perfect body,
Being rich and successful is what everyone ought to be,
Discrimination is so oblivious in our world today.

Poem 28

Not blood of my blood,
Not welcomed to dine,
Not allowed to touch,
Not permitted to watch.

Not required to participate,
Not considered for anything,
Not encouraged to engage,
Not needed anywhere.

Not acceptable to us,
Not approved to go out,
Not recognized by us,
Not welcomed in our midst.

www.ingramcontent.com/pod-product-compliance
Lightning Source LLC
Chambersburg PA
CBHW082241220526
45479CB00005B/1302